Larry Gerber

Camas Public Library

Published in 2012 by The Rosen Publishing Group, Inc. 29 East 21st Street, New York, NY 10010

Copyright © 2012 by The Rosen Publishing Group, Inc.

First Edition

All rights reserved. No part of this book may be reproduced in any form without permission in writing from the publisher, except by a reviewer.

Library of Congress Cataloging-in-Publication Data

Gerber, Larry, 1946–
Getting inked: what to expect when you get a tattoo / Larry Gerber.—1st ed. p. cm.—(Tattooing)
Includes bibliographical references and index.
ISBN 978-1-4488-4616-0 (library binding)
ISBN 978-1-4488-4621-4 (pbk.)
ISBN 978-1-4488-4742-6 (6-pack)
1. Tattooing. I. Title.
GT2345.G47 2012
391.6'5—dc22

2010045970

Manufactured in Malaysia

CPSIA Compliance Information: Batch #S11YA: For further information, contact Rosen Publishing, New York, New York, at 1-800-237-9932.

On the cover: Top: Bottles of tattoo ink are lined up on a shelf at a tattoo studio. Bottom: A studio artist inks a tattoo on the arm of a customer.

mana (ontents managements

	Introduction	4
Chapter 1	Thinking Before Inking	7
Chapter 2	Choosing a Tattoo: What and Where?	17
Chapter 3	Shopping Around	29
Chapter 4	Inking: How Getting a Tattoo Works	38
	Glossary For More Information For Further Reading Bibliography Index	51 53 56 58 62

2

ome of the world's peoples have been tattooing their bodies for thousands of years as part of their cultural traditions or tribal customs. In more recent times, tattoos became popular among sailors, bikers, convicts, and others who were often thought of as existing outside "respectable" society. However, over the past thirty years or so, tattoos have become popular and accepted in practically all walks of life, across all ethnicities, races, classes, professions, and genders.

There are lots of reasons for getting tattoos. Many people simply like the way they look. Others want a "tat" to remind them of somebody they love, living or dead. Some people get tattoos to demonstrate that they are unique. Others get tattoos as a way of showing that they are part of a group. The group might be anything from a circle of friends to a gang, a sports team, or a branch of the armed forces.

Before getting a tattoo—especially for the first time just about everybody has questions. Here are a few of the main ones:

- What kind of design do I want?
- Where should it go on my body?
- How will people react to it?

Introduction

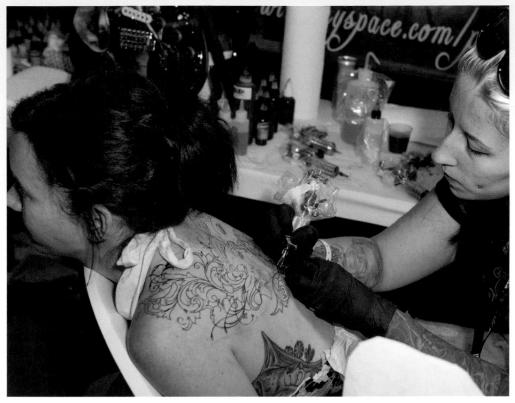

The studio artist Pepper tattoos a customer during the South Florida Tattoo Expo and Car and Truck Show in Deerfield Beach, Florida.

- Will it hurt?
- What will I think of my tattoo years from now?
- How can I avoid getting an infection?
- How do I take care of my tattoo, especially when it's new?

Many of these questions can be answered by experts. Some of the answers will be pretty much the same for most 5

6

people. Others are more personal and can be answered only by the individual getting the tattoo.

This book isn't meant to persuade anybody that tattoos are either good or bad. Instead, it presents all the necessary information relating to the decision-making and tattooing process. It encourages the reader to think carefully about what he or she really wants and make the very best, most well-informed decision that makes the most sense for his or her life, today and years into the future. Getting a tattoo is a perfectly valid and acceptable decision to make, but one must be absolutely sure that it is what is truly wanted. Being true to oneself is the greatest mark of distinction one can wear proudly.

CHAPTER D

Thinking Before Inking

f I want to get a tattoo, it's my skin and my decision. So why should it matter what anybody else thinks?" Lots of people feel this way. Yet the decision whether or not to get a tattoo is a very important one, and it may not involve only the person getting the tat. The answer to the question of "To tattoo, or not to tattoo?" depends on each individual's personal situation.

Rules About Tattoos: Church and State

Age is an important factor when considering a tattoo. In most U.S. states, the legal age of adulthood is eighteen. People under the legal age may get tattoos in some states as long as they have a parent's consent. But in many states, it doesn't matter whether a parent agrees or not; the law forbids giving a tattoo to anyone who's not an adult. For teenagers who want a tattoo, the laws might mean waiting a few months or a few years. That leaves plenty of time to think about the decision, and there are many things to consider.

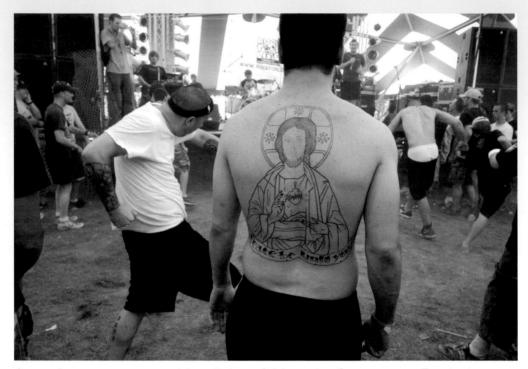

A man's tattoos express his religious faith at the Cornerstone Festival, a four-day long celebration of Christian music, in Bushnell, Illinois.

Some people obey laws they feel are more important than government regulations. Many Christians, Jews, and Muslims believe God's law forbids tattoos for people of any age. They often point to the Book of Leviticus, Chapter 19, verse 28, in the Old Testament or Torah. It says, "You shall not make any cuts in your body for the dead nor make any tattoo marks on yourselves: I am the LORD" (according to the American Standard Version of the scripture).

Some people say that scripture verse doesn't apply to modern tattooing. They believe that the scripture was meant to discourage people in biblical times from cutting themselves to mourn loved ones who had died, which was a custom of some ancient pagan religions in the Middle East. Many Christians and Jews believe that this pronouncement was intended to set true believers apart from unbelievers, not necessarily to ban the kind of body markings and decorations typified by modern tattoos. Faithful people who get tattoos don't feel they are violating their religion. They may even have tattoos of religious symbols or Bible verses.

Others insist that God does indeed forbid tattoos. In the Islamic religion, the law is often clearer than it is for Christians and Jews. Many Islamic teachers say those who get tattoos and those who give them are cursed.

Everybody Has an Opinion

What about the person who has parental permission for a tattoo and who has no moral or religious problem with it? Is there any reason for him or her to consider what other people think about tattoos? It may not seem fair, but the answer is usually "yes."

Right or wrong, positive or negative, there will always be some people who have an opinion about your tattoo. This might not seem important now, especially if friends and family members have tattoos or if most of the people you know think tattoos are cool. But sooner or later, the opinion of someone who doesn't know you is going to make a difference in your life.

Let's say a boss is choosing between two equally qualified applicants for a sales job. The boss likes both candidates. One has a tattoo on his or her hand, and the other doesn't. Even if the boss likes the tattoo, he or she will probably worry about what customers would think of it. In this case, the tattoo is a definite disadvantage.

Tats might also make a difference to a prospective boyfriend or girlfriend, or to that person's family. It's hard to predict the sort of people you'll meet in the future or to know what they'll think about your tattoos.

Health may also be at least a temporary, short-term consideration. Tattoo professionals warn that people with certain physical conditions shouldn't get inked. To avoid infection, people with open sores or lesions should wait until the problem is cleared up before having work done on their skin. Pregnant women should wait until they have their babies before they get tattoos. People who take blood-thinning medications should avoid tattooing as the breaking of skin could lead to excessive bleeding in these cases. Getting a tattoo isn't a good idea for anybody who's sick, even if it's just a cold. Some tattoo artists will refuse to work on people who have coughs or sniffles and will tell them to come back when they're healthy again.

Considering the Reasons

So far we have looked mostly at reasons for not getting tattooed. Now let's consider possible reasons in favor of it. Ask yourself why you want a tattoo. Are the reasons good ones?

1. My friends are getting tattoos: are you feeling pressured to get a tattoo because your friends are also

Thinking Before Inking

11

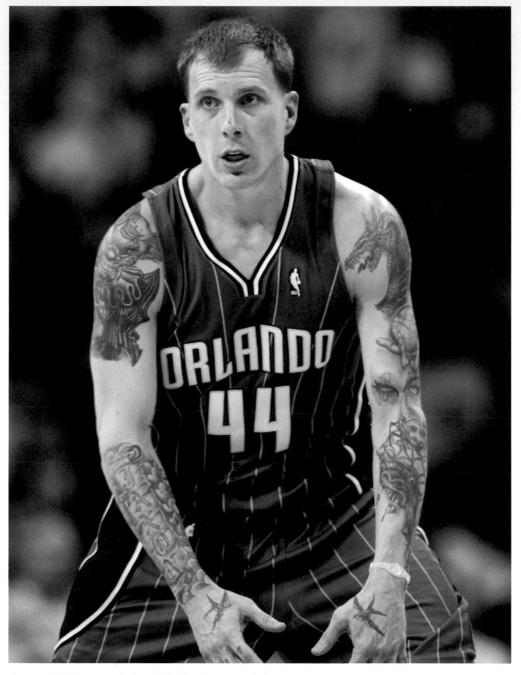

Jason Williams of the NBA's Orlando Magic sports tattoos on both arms, including images of dragons, skulls, and birds.

doing it? For some people, peer pressure can seem overpowering. But as kids grow up, they often get new friends or move to new places. What looks cool to people now in one school or in one town might still look cool years from now someplace else. Or it might not. A tattoo might help you feel like you fit in with one group of people, but it might also make you feel awkward or embarrassed around another group in another setting or later in life.

- 2. Celebrities, musicians, and athletes have tattoos: are there people you admire who have tattoos? Many movie stars, musicians, athletes, and other celebrities like to show off their tats. However, trends and tastes change over the years, and what's hip today will eventually be outdated. Meanwhile, your tattoos stay the same.
- 3. Tattoos can be tokens of commitment to girlfriends/ boyfriends or tributes to family members and friends: Many people get tattoos with names of boyfriends or girlfriends, along with symbols for love or friendship. Unfortunately, those relationships aren't always as permanent as the tattoo. One of the main reasons people go though the pain and expense of getting a tattoo removed is that they have broken up with someone.

But some relationships do last forever. Casey, a music teacher in Oklahoma, has a tattoo of a baby's handprint on his chest. It's a tracing of his son's hand, and he got it right after the baby was born. Susan, who lives in California, especially loved her grandfather. After

13

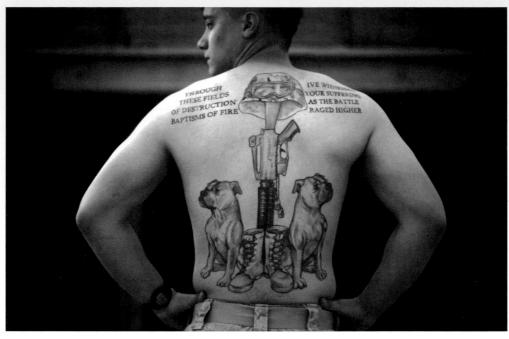

A soldier in Afghanistan shows off his tattoos. The bulldogs refer to a nickname marines use when referring to each other. Along the top of the tattoo are inked lyrics to the Dire Straits song "Brothers in Arms."

he died, she had his name and a personal reminder of him—a cowboy hat—tattooed on her shoulder.

4. Tattoos can celebrate membership in a group of some kind and provide a sense of pride and belonging: many members of clubs, sports teams, bands, college fraternities and sororities, and the armed services get inked to remind them and others of their "tribe." Is group membership a good reason to get a tattoo? To answer that question, it may help to ask other questions: will I always be a member of this group? If not, will I always want a reminder that I once belonged to the group? (\mathbf{O})

Tattoo Fame and Fortune

Dy the time she was twenty-five, Kat Von D was one of the most famous tattoo artists in the world. Her birth name is Katherine Drachenberg. Her parents were missionaries from Argentina, and she was raised in a strict, religious home. As a young girl in Colton, California, Kat embraced the punk lifestyle and started getting and giving tattoos when she was still in her teens.

Older tattoo artists quickly recognized her talent. She worked at several shops in the suburbs of Los Angeles before moving to Hollywood to work. Rock stars and other celebrities began to seek her out. Kat specializes in black-and-gray work, and many of her tattoos look like actual photographs on skin. Lots of people want a tattoo by Kat Von D, and there's a long waiting list for her services.

Kat Von D became a star on the reality TV shows *Miami Ink* and, later, *LA Ink*, which features the colorful comings and goings at her Los Angeles shop, High Voltage Tattoo. She also does other forms of artwork and photography, writes books, and has an art gallery.

6 ave

Many people can answer yes to those two questions, and they're happy with their tattoos. For example, there's a saying about the U.S. Marine Corps: "Once a marine, always a marine." Many people who served in the corps, as well as other branches of the armed forces, are proud of their military tattoos even though they are no longer on active duty. The Marine Corps motto is *Semper Fidelis*, meaning "Always Faithful," and many marines feel that a permanent tattoo denoting membership in the marines is an apt symbol of that faithfulness.

14

Thinking Before Inking

15

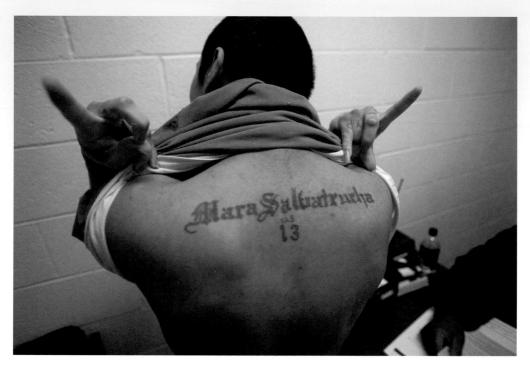

A man reveals his gang tattoo. He belonged to the Salvadoran American gang Mara Salvatrucha-13, composed of Salvadoran refugees who had emigrated to Los Angeles, California.

On the other hand, the Marine Corps has rules against excessive tattoos, such as "sleeve" tattoos that cover the entire arm or forearm and other large tattoos that aren't covered by a uniform. Marines with sleeve tattoos can't apply for officer training.

Imagining the Future

Members of organizations sometimes leave in anger or disagreement. If they have a tattoo symbolizing their membership, they may regret having to wear a permanent reminder of the group. Tattoos, often crude-looking homemade letters and symbols, are popular among many street, motorcycle, and prison gangs. But if members give up gang life, they may wish they didn't have the gang tattoo.

Thinking about a tattoo means thinking about the future as well as the present. That's not always easy to do. If something seems like it's important or a lot of fun in the present moment, we tend to think that it will always feel important or fun. But as time passes, people change, as do their attitudes. Some people simply "outgrow" their tattoos and get tired of them as they get older. Reality TV star Kelly Osbourne said in 2010 that she would have some of her fifteen tattoos removed, even though she wasn't looking forward to it. "When I was younger, I really do think that tattoos were my way of self-harming because I really knew it would upset my mum and dad," she is quoted as saying by Bloginity.com, an online magazine for culture and entertainment news. "I was miserable and I just went and got all these tattoos and I don't know why."

Tattoos are permanent. That's why it's important to take the time and do some hard thinking before deciding whether to get a tattoo. If the answer is, "No, I don't want a tattoo," that's the end of the questions. If the answer is, "Yes, I do," the questions are just beginning.

Choosing a Tattoo: What and Where?

TER 2

attoos come in all shapes and sizes. At one time or another, people have put tattoos just about anywhere and everywhere on the human body. Today, a person looking for a tattoo design may choose from thousands of pictures, words, quotations, symbols, and combinations of all of these.

Most tattoo shops poster their walls with "flash," which are ready-made designs. They also offer catalogs and Web sites with hundreds of illustrations. However, many people want a design of their own making, or they may have an idea of their own and want an artist to help them express it. Whether the design is original or comes from an artist, everyone who gets a tattoo has to think about where to put it and how big it should be.

When considering what and where and how big, it helps to keep in mind the same questions we asked about getting a tattoo in the first place: what will I think of it years from now? What will other people think when they see it?

Flash papers the wall of this tattoo studio as a tattoo artist inks a customer.

Size and Placement

Tattoos on certain parts of the body—wrists, neck, forearms will usually be seen no matter what kind of clothes we're wearing. Anybody considering a tattoo on one of those spots should probably think very hard about it. Tattoos in those places will be seen by just about everybody with whom one

18

comes into contact. On the other hand, tattoos on the back, chest, and shoulders are often covered up by clothing. They probably wouldn't be seen by a job interviewer or by anyone else in a position to judge a person on the basis of appearance.

Body placement also affects the design and size of a tattoo. An artist would obviously have trouble tat-

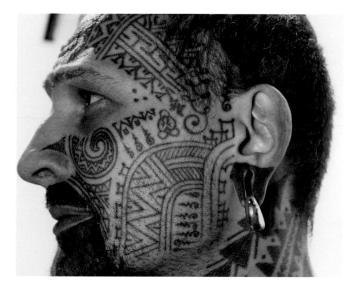

A man displays his facial tattoos at an international tattoo convention held in London, England.

tooing an intricate design or a long quotation on somebody's hand or finger. And a tiny picture or symbolic letter might look strange tattooed all by itself on the expanse of someone's back or chest.

The bigger the tattoo, the more room there is for detail in the design. Bigger tattoos are also likely to make bigger impressions—for better or for worse—on people who see them. How big is big? The Marine Corps, which has the strictest tattoo regulations of any of the armed forces, doesn't allow visible tattoos bigger than a man's hand.

Placement on the body not only determines how visible a tattoo is to other people, it also affects the way tattoos age how the ink will look when the skin gets thinner and more

wrinkled. Tattoos on parts of the body that move a lot, such as hands and fingers, usually fade and wrinkle sooner than tattoos on other parts of the body. If a tat is in a spot that's usually covered with clothing, it won't fade as much as a tattoo that's often exposed to the sun's ultraviolet light.

Some parts of the body hurt more than others when they're being tattooed. Areas where the skin is thin or close to joints or bones are more painful. People with lots of tattoos say the most painful places are the spine, feet, ankles, chest, ribs, elbows, inside of the wrist, behind the ear, and around the eyes. The least painful places are the shoulders, arms, and thighs.

A Wide World of Design

Many modern tattoos are inspired by designs that are thousands of years old. They are taken from peoples and cultures around the world. Here is a look at some of the tattoo styles that have been popular in recent years.

• **Celtic designs** are intricate knots and mazes, usually done in black or blue ink only. They are inspired by centuries-old pieces of Celtic art and craftwork, particularly those found in Ireland. Celtic designs are more difficult than others to tattoo. It's recommended that customers who want a Celtic tattoo find an artist who specializes in them.

An intricate Celtic knot graces the back of this young man.

• Asian or Oriental is a broad category of tattooing that encompasses many cultures and traditions, including Japanese and Chinese tattoo styles. Many people favor simple tattoos of Japanese or Chinese text characters, while others decorate their entire bodies with symbolic carp, dragons, blossoms, and other decorations in the Japanese style.

- Polynesian tattoos—inspired by the island cultures of the Central and South Pacific—had a strong influence on modern tattooing. The word "tattoo" comes from the language of Tahiti, one of the islands in French Polynesia. Sailors who traveled in the Pacific during the Age of Exploration introduced Polynesiantype tattoos to Europe and America. Tahitians, Hawaiians, Maoris of New Zealand, Samoans, Tongans, and other native island peoples all have their distinctive styles.
- Native American designs figure in many modern tattoos. The best-known style is called Haida, the tribal name of a people in western Canada and southeastern Alaska.
- Tribal tattoos may resemble Polynesian or Native American designs, but they are often made up of abstract lines and swirls, rather than images of specific things. Most of them are done with black or blue ink only.
- Traditional tattoos are usually inked in bold lines and bright colors. They include classic images like an anchor or a heart with "Mom" written on a scroll that is draped across the heart. The traditional style is thought to have started on U.S. military bases after World War I.
- **Military** tattoos include symbols of a service branch, such as an aviator's wings for the U.S. Air Force or

the eagle, globe, and anchor of the Marine Corps. U.S. Army veterans often choose a replica of their unit patch, while U.S. Navy and Coast Guard veterans may pick tattoos featuring ships or anchors. Men and women in all services frequently get tattoos honoring comrades killed in action.

- **Religious** styles of tattooing may include crosses, Bible verses, or Hebrew letters representing words that are important to the wearer.
- Biomechanical motifs were inspired by illustrator
 H. R. Giger, who designed the creature from the *Alien* movies. They usually show muscles intertwined with machine parts.
- **Biker** tattoos often feature motorcycles, wheels, flames, women, skulls, and motorcycle gang logos.
- **Gothic** tattoos may include bats, vampires, or other spooky images.
- Black-and-gray is a tattooing style that is thought to have originated in prisons, where artists couldn't get colored inks and instead used ink made from ashes or other available material. Professional black-and-gray tattooing features subtle shading, which requires a lot of skill by the artist.
- **Realistic** tattoos, also called portrait or photographic tattoos, also require special artistic skill and experience. They are usually done in black-and-gray, and they often look just like photographs or paintings.

A father's tattoo honors his deceased infant son.

Personal Tattoos

For many people, tattoos are a form of individual expression, so it makes sense for them to want an image that's unique, even one that they have designed themselves. Customers can take their own drawings to an artist, who will help them refine the idea and sketch out a design that can be tattooed.

Designs that include names have been popular for a long time, but many artists are reluctant to tattoo the name of a friend, boyfriend, girlfriend, or even a wife or husband. They worry that the relationship will not last and that the wearer will come to regret get-

ting the tattoo. The wearer's own name, as well as names honoring parents, grandparents, children, brothers, sisters, and loved ones who have died are safer because the importance and meaning of those relationships are less likely to change negatively over time.

Traditional Tattoo Symbols

ON19

■ raditional" is the name for the style of tattooing that became popular in the United States between World War I and World War II. Many military tattoos are examples of the traditional style. Here are a few of the bestknown motifs.

- **Anchor:** A longtime favorite of sailors. Many anchors are an anchor-cross design, which also has religious symbolism.
- **Heart:** The classic symbol of romantic love, hearts can take on alternate meanings when they are tattooed with other elements, such as the word "Mom" or when they are shown broken in two or pierced with a dagger.
- **Star:** There are many tattoo versions of stars, and they mean different things, depending on their shape and orientation. Some look like compass points and might indicate that the wearer is a sailor or someone who knows where he or she is going. The sixpointed Star of David is a Jewish symbol.
- **Rose:** Popular with both men and women, roses usually symbolize true love.
- **Cartoons:** Many traditional tattoos are cartoon characters: Popeye, Donald Duck, Betty Boop, Road Runner, and Mickey Mouse are just a few.
- **Cross:** The Christian symbol is a favorite subject for traditionalstyle tattoos. It also appears in many other tattoo styles, particularly Celtic.
- **Luck:** Both good luck and bad luck have a number of symbols in traditional tattooing. Good luck signs include horseshoes, four-leaf clovers, and the number seven; bad luck signs include the number thirteen, black cats, and the eight ball.

If a tattoo includes writing, the customer needs to decide what font, or style of lettering, to use. There are hundreds of fonts to choose from, and the choice of font is an important decision. Some fonts make letters jump out at the viewer. Others make the lettering harder to read. Sometimes words are blended with pictures or designs so that they can't be read at all without looking closely. Popular types of font include:

- **Gothic** or "blackletter" styles. The best-known font in this category is Old English.
- **Celtic** or "uncial" lettering
- **Graffiti**, which includes many styles of modern writing as well as street scrawl
- **Cursive** handwriting, either the wearer's own style of script or one of many ready-made cursive fonts
- Kanji, the Japanese version of Chinese calligraphy
- Hanzi, traditional Chinese writing

Other writing styles include "icy" and "fiery," which aren't actual fonts but ways of making letters that look frozen or seem to be burning.

English and most other European lettering systems are based on the Roman alphabet. Other lettering includes Arabic; Sanskrit, an ancient language of India; Cyrillic, the alphabet of Russia and other Slavic countries; and the Chinese and Japanese systems. Some tattoo inscriptions are in made-up alphabets, such as the "Elvish" runes from J. R. R. Tolkien's *Lord of the Rings* trilogy. Examples of fonts and

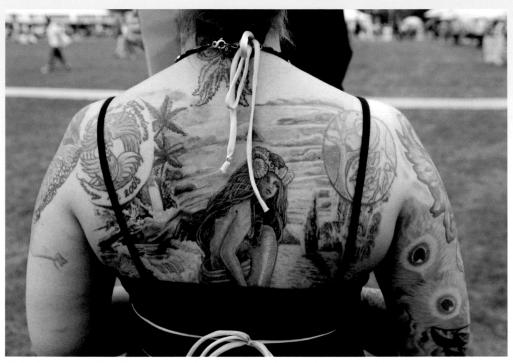

This Monroeville, Pennsylvania, tattoo artist is also an avid tattoo wearer.

styles can be found on the Internet or in the flash illustrations at tattoo shops.

Images

Unlike words, images can mean lots of things, depending on who's looking at them. Traditional flash pictures include hearts, anchors, butterflies, daggers, the yin and yang symbol, skulls, and stars. Custom images can be spectacular: scenes of heaven or hell, the face of a loved one, fountains, rockets, weapons, famous artworks, bizarre creatures, or elaborate abstract designs. Whatever sort of picture or design you choose for a tattoo, it's important to remember the two basic questions that must be asked throughout the decision-making process: will I be happy with it years from now? What will others think about it?

Abstract designs are often safer than words or pictures of specific things, in terms of how you will think of them in the future and how others see them. To say something is abstract means that it doesn't depict a specific image. Abstract tattoos are usually intended to decorate a part of the body, rather than to pass on a message. Many tribal designs are examples of abstract tattoo art. They may include bands circling an arm or a leg, or strips or curls that flow with the natural curves of the body. They are sometimes done with color but more often in dark ink only.

Many Americans and Europeans who get tattoos choose Kanji or Hanzi characters because they look good as designs. Their meaning is clear only to the wearer and a few others. Because their meaning is often obscure to Westerners, Asian-character tattoos are often seen as special, exotic, or mysterious. Typical choices include the characters for strength, love, life, happiness, friendship, and other concepts. Other popular characters are signs of the Chinese zodiac, particularly those of the wearer's birth year: snake, dog, monkey, ram, rooster, and so on. Or the wearer may simply choose a character with a symbolic meaning he or she likes, such as a dragon, tiger, or cherry blossom.

Shopping Around

etting a tattoo for the first time is exciting. Once the decision has been made and a design has been chosen, it might be tempting to head for the nearest shop right away and just get the work done. However, people with lots of tattoo experience—as both artists and customers—recommend taking plenty of time to shop around and ask questions. Anyone thinking about getting a tattoo must find an artist they feel comfortable with and who will be able to provide the design he or she wants in a safe and clean environment. The artist should also be willing to patiently and knowledgeably answer all questions and concerns.

SHAPTER 3

Important Questions to Ask

Here are a few of the questions that need answers: Does the artist know how to ink the sort of tattoo I want? Have I seen samples of his or her work? What do other customers say? Is the artist a good listener? Does he or

she answer all my questions? Do I get along OK with the artist? Do I feel comfortable in the shop? Is it safe and sanitary? Is there one main style that stands out in the artist's portfolio? It may also help to ask the artist what his or her favorite style is. Chances are, that's the style he or she is best at. But is it the style that is wanted?

Seeing Is Believing

Finding the right artist often starts by first finding a happy customer. If someone is wearing a tattoo that looks appealing, ask who did the work and what the wearer thinks of the artist. Friends can give the most trustworthy advice about a particular artist or tattoo shop based on whether they've had a good experience or a bad one. The more people you ask, the more you will learn. Talk to your friends and relatives about it and go to multiple shops as well to watch and talk with artists and customers. Take your time to get the whole story.

At first, it may seem awkward to ask strangers or people you don't know very well, but most people like to talk about their tattoos and might even be flattered by the interest. Talking to customers not only gives a feel for what the artist is like, it's also a chance to see how the artist's work looks on real skin.

It's impossible to evaluate an artist without looking at his or her work. Many shops line their walls with pictures, and they may post a lot of pictures on their Web sites. But there's not always a way to be sure they are the actual work of the artist. Most reputable artists keep a photo album of their tattoos, and the portfolio usually has a signature or some kind of authenticating note that the samples were actually done by the artist.

When looking at the examples in the portfolio, check closely to see if the lines of the tattoos are smooth and clean. They shouldn't be shaky, jagged, or blurry. Lines should connect where they're supposed to connect. Squares and circles ought to look really square and round, not distorted. Colored areas should look solid, and colored spaces should be filled

This tattoo artist maintains an online portfolio of his work.

in evenly. The tattooed skin in some of the example pictures might look red and puffy, but that's probably because the pictures were taken right after the tattoos were inked, before the customers left the shop. It's still possible to get an idea of the basic quality of the work. By looking at a variety of the artist's samples, a potential customer can also get a good idea of how much experience the artist has with the kind of tattoo that is desired.

It's wise to visit as many shops as possible before making a final decision. Studio artists understand the uncertainty and anxiety that comes with getting a first tattoo. Real pros will be patient and friendly when it comes to answering questions and making customers comfortable. If they're not, it's time to look somewhere else.

Getting a tattoo should be fun. Finding an artist who's easy to talk to and offers information goes a long way toward making it an enjoyable experience.

Choosing a Clean and Safe Shop

Getting a tattoo should also be a safe experience. Since tattooing punctures the skin and draws blood, there's a risk of infection. When shopping for the right tattoo parlor, look around carefully to see if the place is clean. A shop may have funky décor and weird lighting, but it should never be dirty. And the area where tattoos are actually applied should have plenty of light. Artists should be neat and clean in appearance and wash their hands frequently.

The most serious health threat in tattooing is from bloodborne diseases. These include HIV (the virus that causes AIDS), hepatitis, and tetanus. Hepatitis is the biggest worry as this organism, given the right conditions, can live on the surface of

i

Shopping Around 33

furniture, phones, chairs, and the environment for up to two to three months. Even a small scratch by an infected needle may transmit hepatitis, which can damage the liver. HIV can also be spread by infected needles or other implements that come in contact with human blood. The Alliance of Professional Tattooists, citing information from the Centers for Disease Control and Prevention. says there haven't been any documented cases of AIDS contracted by professional tattooing in the United States.

To reduce the risk of infection, all tattoo equipment must be properly used

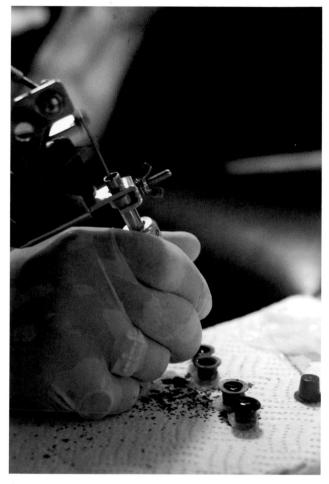

A tattoo gun dips into a single-use ink cap.

and sterilized. Anything that comes in contact with the skin or blood during the tattooing process should either be sterilized in an autoclave after use or put into a hazardous waste container for disposal. An autoclave is a machine that sterilizes needles and other equipment with high-pressure steam. If a shop doesn't have an autoclave, don't get tattooed there.

C

و

What Does It Mean?

Jome tattoos are abstract decorations, while others have words and symbols whose meanings are explicit and clear. Here's a look at a just a few of the more popular symbols and what they mean:

- **Ambigrams:** Ambigrams are graphic figures that mean the same thing—or sometimes the opposite thing—when they are viewed backward, upside down, or in a mirror. They may be words, images, or abstract designs. For example, an ambigram may look like an angel in one view, but turn it upside down or look in a mirror, and the angel becomes a devil.
- **Fish designs:** Fish designs are popular symbols in many cultures, and fish appear in many tattoo styles, including Celtic, religious, Native American, Polynesian, Asian, and many others. In Chinese tradition, the goldfish symbolizes good fortune, and the carp may represent wisdom and loyalty.
- **Eagles:** Eagles, in various forms, have been a popular tattoo subject for hundreds of years. In several ancient cultures, the sun god was represented by an eagle, and the eagle is prominent in cultures from Scandinavia to Mexico. Today, eagles symbolize patriotism, particularly in the United States.
- **Dragons:** Dragons appear on tattoos around the world, but the dragon may mean different things in different places. In Europe and America, the dragon is traditionally a fearsome enemy who breathes fire and is battled by a brave warrior. In Asia, the dragon is more friendly and is often viewed as a force for good.
- **Flowers:** Flowers may represent life, death, birth, rebirth, and many other ideas depending on the type of flower. The rose is especially significant in Western cultures, and the lotus has special meaning in Eastern cultures.

Shopping Around

35

Many states have strict health regulations for tattoo shops, and operators in these states are usually required to keep records of autoclave use, showing that their equipment is sterilized after each use. Shopkeepers should be happy to show their health and safety records to any customer who wants to see them, and it's always a good idea to ask. When you enter the shop, look around for some posted state regulation form that tells you that this studio has registered with a state agency and adheres to the regulations. If they have it, it should be posted. If they don't have it, don't use that studio. While tattooing, artists should always wear disposable surgical gloves. Many artists, to be on the safe side, also get vaccinated for hepatitis. When talking to a prospective artist, it never hurts to ask whether he or she has been vaccinated.

All tattoo equipment is supposed to be "single-service." Needles come in sealed containers and should be used only once. Then they are either sterilized in an autoclave or put into a "sharps" container for disposal. Ointments, gloves, razors, tubes, wipes, and liquids should also get thrown away after each use. They must be placed in hazardous waste containers, not in the regular trash can or the sink. Before tattooing, ink is placed in one-time-only "caps" that hold just enough for each tattoo. When the process is done, the containers should be thrown away, along with any leftover ink. The leftover ink can't be used because it has come in contact with another person's blood and bodily fluids.

Many states and cities require tattoo artists to get licenses or register with health authorities and have regular inspections

in their shops. Tattoo professionals may also be required to undergo health safety training. Look around to see if the shop displays licenses, health certificates, or state and/or city registration. If you're not sure what the regulations are in your area, ask. Artists and staff should have no problem giving details about their training, experience, and safety procedures.

Tattoo artists themselves will tell you to beware of "scratchers." And there are plenty of them out there. That's the term for someone who doesn't have formal training but provides tattoos anyway. Scratchers may work in homes, basements, flea markets, or garages, often using a cheap tattoo kit. Many scratchers fail to sterilize and maintain their equipment properly, and many of them save money by

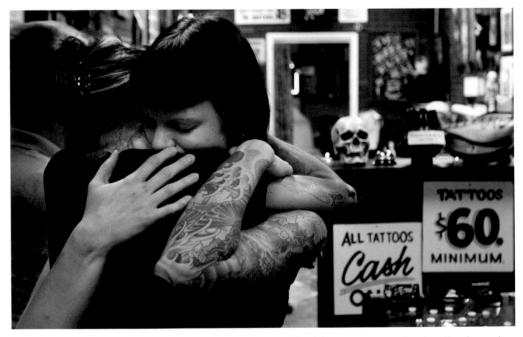

The excellent work of this St. Petersburg, Florida, tattoo parlor is displayed on the arm of this woman.

reusing needles and other equipment. This is very dangerous because of the risk of infection and deadly disease it poses.

(ost

Shopping around to find the best place to get a tattoo doesn't necessarily mean shopping around for the cheapest price. Since tattoos are for life, quality work is much more important than trying to save a few dollars.

Tattoos are usually paid for by the piece or by the hour. Flash tattoos are usually a standard price, and often the shop's catalog of flash will include prices. In most places, a stock design about 2 inches square (5 centimeters) will probably cost \$100 or less and take about an hour to complete. Prices vary a lot from place to place. Popular or well-known artists are usually more expensive than those who aren't so well known.

For larger tattoos, the artist will usually charge by the hour. Customers who bring their own designs can also expect to pay by the hour. Customers with limited funds can tell the artist how much money they have to spend and ask if it's possible to get the tattoo they want for that price. Once the artist quotes a price, it's not a good idea to try to bargain it down. Tattoo artists are professionals, with their own standards, and they may take offense if someone seems to be trying to cheapen or devalue their work.

Tattoo artists, like most other service professionals, appreciate tips. Ten to 20 percent is the usual rate. And artists always appreciate it when customers recommend them to others.

Inking: How Getting a Tattoo Works

fter making all the critical decisions, actually getting the tattoo is probably the easiest part of the process. Anyone who has taken the time to find the right design and the right person to do the work can relax a little. But remain alert during the entire process to make sure you get the product you want and all safety and health precautions are being followed properly.

Getting Ready

After making the final decision to get a tattoo at a certain shop, the next step is to make an appointment. Don't just drop in without a reservation expecting to immediately get the tattoo and artist you want. Tattoo artists are very busy professionals with many clients. To ensure getting the artist you want and the proper amount of time to ink the tattoo you want, call ahead and make an appointment.

Before going to the shop, it's important not to take aspirin or any other medication that thins the blood. Alcohol is also a bad idea.

Inking: How Getting a Tattoo Works

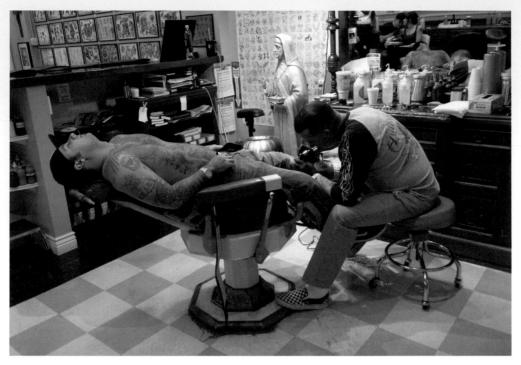

A customer in this Sacramento, California, studio receives a tattoo on one of the few remaining uninked parts of his body.

Alcohol and blood thinners can inhibit clotting and cause heavier bleeding. There will be some bleeding when the tattooing starts because the skin will be broken, but excessive bleeding can hamper the tattooing process and increase the chances of receiving an inferior tattoo. Excessive bleeding is also a health risk. It's a good idea to be rested up and to have eaten some food. People who are tired or who have low blood sugar may experience more discomfort or may even faint.

When it's time for the work to start, the customer will be taken to the tattoo chair, usually in a separate room or section of the shop. Some tattoo artists use dentist chairs or recliners. Some studios just have regular chairs. The artist may ask if it's OK for someone else to watch the work, usually somebody who's considering getting a tattoo and wants to know how the process works before committing.

To begin the preparation, the artist will put on latex gloves and scrub the customer's skin with alcohol or some other cleaning agent. Then the tattoo area is shaved. The artist should use a new, disposable razor. Shaving is important because otherwise the needle may push hair under the skin, thereby increasing the risk of infection.

Next, the design will be drawn on the skin to give the artist a guide to follow when applying the ink. Sometimes the design may be drawn directly onto the skin, but most often the artist will use a stencil. The area is then coated with deodorant, alcohol, or soap to make the transfer easier and leave clear lines. The stencil stays on for a minute or so to let the design transfer. When the artist removes the stencil, he or she will probably ask the customer to check the design in the mirror to make sure it's straight and in the right place. If it doesn't look right for any reason, now is the time to say so. This is the last chance to make adjustments. It's also the last chance to back out of getting the tattoo. It's fine to change your mind at this point. A professional tattoo artist will understand and respect your decision.

Getting Inked

When it's time to start inking, the artist will pour the pigments from large storage containers into small ink cups, also

Inking: How Getting a Tattoo Works

called ink caps. The thimble-sized containers hold enough ink for one tattoo, and they should be thrown away after a single use. Don't ever let an artist use a partially used container from someone else's tattooing. The artist will open a sterile pouch of needles and tubes. This "autoclave pouch" has a dot that changes color to show that the equipment inside has been sterilized. The pouch should be unsealed in front of the customer. The artist will then assemble the tattoo equipment, turn on the machine, and get ready to apply the tattoo. Some people dislike the buzzing sound that the tattoo machine makes—it sounds sort of like a dentist's drill—and they come prepared with an MP3 player and ear buds or headphones to drown it out.

The first step in applying the tattoo is doing the outline. This part usually hurts worse than the coloring and shading that come later. Pain tolerance varies from person to person. Some people say tattooing doesn't hurt much at all. Others compare it to a sunburn, a bee sting, a cat scratch, or even a burn from an open flame. It's important to relax. Tensing up will just make the pain worse. The artist may use just a single needle for a thin line or a set of several needles for thicker areas. Multiple "liner" needles are usually arranged in a circle.

The first few lines usually hurt the most. If someone is getting a first tattoo, the artist will usually pause after the first strokes to see how the customer is doing. If he or she is queasy or faint, the artist will probably stop a minute to let the customer take some deep breaths before continuing. If the discomfort gets to be too much at any time, there's nothing

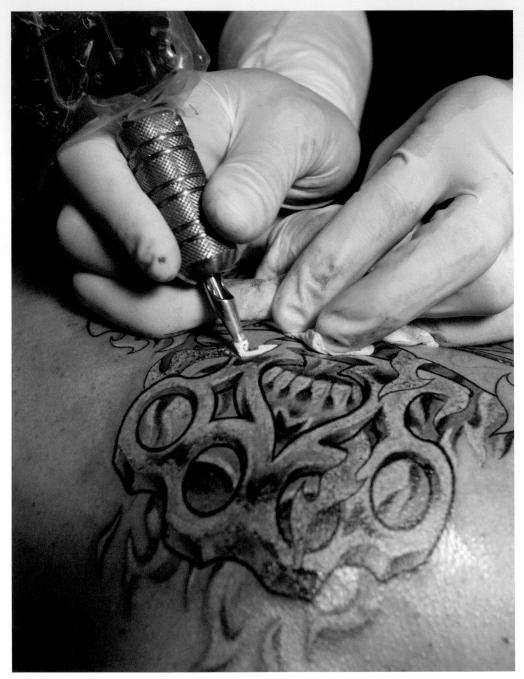

A vividly colored tattoo is inked on this customer during the Body Art Expo in San Francisco, California.

wrong with asking the artist to stop for a minute to allow a stretch or a bathroom break.

As the artist inks the outline, using thin ink, he or she will stop the machine from time to time to wipe away the transfer ink and any blood. Artists usually work from the bottom up so that they don't smear the stencil outline. When the outline is finished, the artist will remove any remaining traces of transfer ink and clean the tattoo.

The next stage involves shading and coloring. The needles will have to be changed, so this might be a good time for a break. Using a variety of needles and a thicker ink, the artist goes over the design making clear, solid lines. The needles, known as shaders, may be set in a straight line, like the teeth of a comb. The tattoo is cleaned again before color is applied. Color inking can be uncomfortable, but it's usually not as painful as the outlining. When applying color, the artist makes each line overlap so that there are no "holidays," or spots where color is missing. After inking, the artist cleans the area again with a disposable towel, then puts a sterile bandage on it. Oozing of fluid or slight bleeding usually stops a few minutes after the process is finished. How long the entire tattooing process takes naturally depends on the size and intricacy of the tattoo. Larger designs may take more than one visit to complete.

Equipment and Ink

What's actually happening when an artist inks a tattoo? He or she is using an electrically powered "gun" that moves a

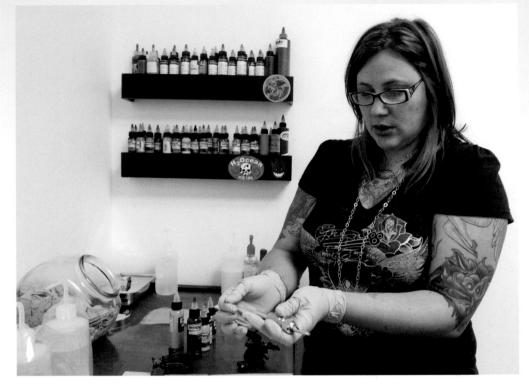

A studio artist prepares and sterilizes her tattoo equipment before beginning to ink a customer in Decatur, Alabama.

needle up and down from fifty to three thousand times a minute. The needle punctures the skin about .04 inches (1 millimeter) deep each time it goes down, leaving a drop of ink behind. The artist regulates the machine with a foot pedal, much like a sewing machine pedal.

Most tattoo inks aren't really inks at all, but various kinds of pigments in a disinfecting solution that spreads the colors evenly. Manufacturers aren't required to reveal what's in their pigments, and the contents are usually regarded as a trade secret. They aren't regulated by the U.S. Food and Drug Administration (FDA). Some reports have found printer's ink and automobile paint in tattoo pigments. Some colors like red and yellow include such harsh chemicals that they have caused allergic responses or sun sensitivity. Always insist on American brand pigments.

Most pigments are mineral based, while others are vegetable based. Some of them, especially the colored ones, can cause allergic reactions. Red and yellow cause the most reactions. Some pigments glow in the dark or are visible only under ultraviolet light. These pigments have a risky reputation. While some of them are safe, others may cause radiation poisoning or other toxic reactions.

New Tattoo Care

Tattoo shops should give the newly tattooed customer a pamphlet on caring for the tattoo. It's important to follow the precautions listed there and use proper care to keep the tattoo from fading, getting distorted, or getting infected. Here are some common guidelines for taking care of a new tattoo:

- **1.** Remove the bandage when recommended, usually one or two hours after the procedure.
- 2. Wash the tattoo two or three times a day for the first week, using cool or lukewarm water and a mild antibacterial soap.

45

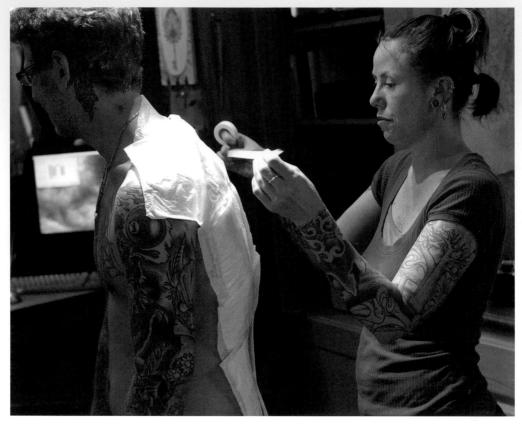

A tattoo artist bandages her customer's back after a seven-hour session in her studio in Phoenicia, New York.

- **3.** Don't soak the tattoo in water for a long time or put it directly under the shower.
- 4. Pat it dry. Don't rub!
- 5. Don't let clothing or anything else rub or irritate the new tattoo. If the tattoo is on an ankle, it might be good to avoid wearing socks for a while. If it's on the small of the back, make sure the waistband of pants or skirts doesn't chafe it.

- **6.** When applying antibacterial ointment, put on a very thin coat and gently work it into the skin. Too much ointment might take color out of the tattoo.
- 7. After three or four days, start applying a thin coat of unscented lotion, rather than antibacterial ointment, to keep the tattooed skin moist. Don't use petroleum jelly, products with aloe, or anything that clogs the pores. The tattoo needs to breathe.
- **8.** Keep the new tattoo out of direct sunlight and stay out of the swimming pool until it's healed. Sun and chlorine can fade tattoos.
- **9.** There will probably be scabs. Let them heal naturally and fall off. Don't pick at them. If the skin itches, slap it lightly or apply a thin layer of lotion. Don't scratch.
- 10. Call the doctor if there's any sign of infection. Signs of infection include red or puffy skin and tenderness to the touch. If a tattoo is healing properly, it won't be very painful to the touch after three or four days.

In general, follow the advice of the person who gave the tattoo. Studio artists know about aftercare and want their customers to be happy with their tattoos. For the first two or three days, blood, body fluids, and ink may continue to seep out of the tattoo. This is normal. During this time, most people wear clothes that they don't mind staining, and they may put a cloth on the bed at night to keep stains off the sheets. With proper care, the tattoo should heal in three to six weeks.

Safety Suggestions

Jafe tattoo artists take many of the same precautions against infection that doctors and dentists do. Here are a few things to watch for during the process to make sure that the artist is playing it safe.

- The artist makes a point of removing the new needle and tube setup from a sterile pouch while the customer is watching.
- The artist pours ink into disposable ink cups in front of the customer.
- The artist puts on a new pair of disposable gloves before setting up tubes, needles, and ink.
- The artist has no problem answering questions about sterile procedures, his or her safety record, and his or her training in avoiding infections. The artist should also display or present upon request any state or city operating licenses and health board certificates.

No

Removing Tattoos

Most experts say it's impossible to completely remove every trace of a tattoo, but several newer methods of laser removal work better than methods used in the past. It's hard to predict how many traces of a tattoo will remain after removal, mostly because it's partly determined by what kind of ink was used initially. There are dozens of kinds of tattoo ink.

48

Inking: How Getting a Tattoo Works

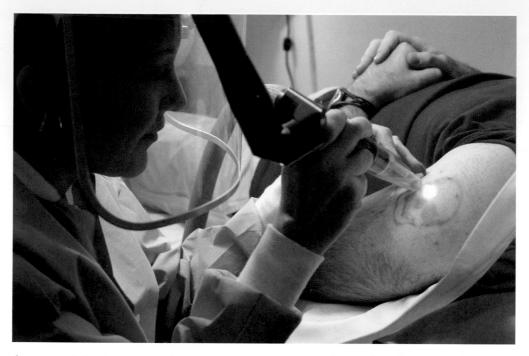

A cosmetologist uses a laser to remove a tattoo from the shoulder of a client at a laser hair removal clinic in New York City.

Other factors that affect how thoroughly a tattoo can be removed include placement, size, and how long it has been in place. It is often harder to remove a new tattoo than an old one.

Laser surgery is the most effective way to get rid of a tattoo. The laser penetrates the skin and breaks up tattoo pigments so that they can be carried away naturally by the body's immune system. It may take several laser treatments, each about three weeks apart, to get rid of a tattoo. Black is the easiest color to remove because it absorbs more of the laser waves. Green and yellow are more difficult to remove.

Laser surgery can be painful. Some people compare it to little dots of hot grease being applied to the skin. Laser surgery can also be expensive. Some treatments cost several thousand dollars. Other methods of tattoo removal include dermabrasion, or sanding the skin; cryosurgery, or freezing the skin; and excision, or cutting away the tattoo with a scalpel and stitching up the wound.

It should be remembered that traces of a tattoo almost always linger after tattoo "removal." A tattoo, once applied, can never be completely erased. There will always be at least a partly visible remaining ghost mark or after-image where the tattoo once was. Tattoos are forever, so think hard about the decision to get one. Consider future scenarios that involve how people will view your tattoos. Think carefully about the image or words you want tattooed and where you want to have them tattooed. Do research about the best and safest artists and shops in your area. And, whether you ultimately opt to tattoo or not to tattoo, be happy, secure, and comfortable with your decision.

- **AIDS** Acquired immunodeficiency syndrome; a serious and often fatal disease that's usually transmitted through contaminated needles, sexual contact, or blood products.
- **autoclave** A machine that sterilizes equipment using highpressure steam.
- **biomechanical** A style of tattoo art that shows human muscles mixed with machine parts.

calligraphy An artful way of drawing letters or characters.

- **Celtic** Referring to an ancient people of Europe whose culture survives in Ireland and parts of Great Britain, Spain, and France.
- **Chinese zodiac** A system of counting time in cycles of twelve years, with each year named for an animal.

font A set of print characters that share a specific style.

- **hepatitis** A potentially fatal inflammation of the liver caused by a virus or toxic substance.
- **HIV** Human immunodeficiency virus; the virus that causes AIDS.
- intricate Having a lot of fine or complicated details.
- lesion A wound or injury, especially on the skin.
- **obscure** Having hidden meaning; difficult to find, discover, or comprehend.

pigment Coloring material; a substance that provides color.

- **placement** The deliberate situating of an object in a certain place.
- **Polynesian** Referring to the people and culture of the Central and South Pacific islands.
- **portfolio** A collection of samples of an artist's work, usually contained within a book, large carrying case, or, increasingly, within digital folders or on disc.
- **reputable** Having a good reputation; trustworthy, reliable, or legitimate.
- **scripture** Writing that is regarded as sacred by a religious group.
- **sleeve** Tattooing that covers a person's entire arm or forearm.
- **sterile** Free of bacteria and other organic matter that can cause infection.

FOR MORE INFORMATION

Alliance of Professional Tattooists (APT)

215 West 18th Street, Suite 210 Kansas City, MO 64108 (816) 979-1300

Web site: http://www.safe-tattoos.com

The APT provides information about how to get tattoos safely, what to expect, and other facts provided by tattoo professionals. Its pamphlet "Basic Guidelines for Getting a Tattoo" and other materials are available on its Web site.

American Academy of Dermatology

P.O. Box 4014 Schaumburg, IL 60168-4014 (866) 503-7546 Web site: http://www.aad.org The academy's Web site features a directory of dermatologists and advice on getting tattoos.

Canadian Public Health Association

400-1565 Carling Avenue Ottawa, ON K1Z 8R1 Canada (613) 725-3769 Web site: http://www.cpha.ca/en/default.aspx This nongovernmental public health association publishes information about

tattoo safety guidelines on its Web site.

National Tattoo Association

485 Business Park Lane Allentown, PA 18109-9120 (610) 433-7261

Web site: http://www.nationaltattooassociation.com The association provides tattoo safety information, news, contact information for professionals, and pictures of the work of member tattooists in the United States, Canada, and other countries.

Public Health Agency of Canada

130 Colonnade Road A.L. 6501H Ottawa, ON K1A 0K9 Canada (613) 957-2991

Web site: http://www.phac-aspc.gc.ca The agency's Web site includes reports on tattooing, blood-borne diseases including hepatitis and HIV, and other information.

Society of Permanent Cosmetic Professionals

69 North Broadway Des Plaines, IL 60016 (847) 635-1330

Web site: http://www.spcp.org The society provides information about cosmetic tattooing and a directory of professionals. The society also has a Canadian directory of tattoo professionals.

Tattoo Artists Guild (TAG)

Web site: http://www.tattooartistsguild.com

55

The Tattoo Artists Guild is an international association of dedicated and responsible members working to elevate and advance the art of tattooing. All members of the Tattoo Artists Guild agree to support and follow a basic set of standards of practice to maintain a high level of integrity in the tattoo-ing industry and help ensure a safe working environment for the general public and for the tattooist.

Web Sites

Due to the changing nature of Internet links, Rosen Publishing has developed an online list of Web sites related to the subject of this book. This site is updated regularly. Please use this link to access the list:

http://www.rosenlinks.com/ttt/gi

FOR FURTHER READING

- Fulbeck, Kip. *Permanence: Tattoo Portraits by Kip Fulbeck*. San Francisco, CA: Chronicle Books, 2008.
- Hart, Carey, and Bill Thomas. *Inked*. New York, NY: Artisan, 2008.
- Hemingson, Vince. *Tattoo Design Directory*. Surrey, England: Chartwell Books, 2009.
- Hudson, Karen L. *Chick Ink: 40 Stories of Tattoos and the Women Who Wear Them.* Avon, MA: F+W Publications, 2007.
- Kakoulas, Marisa. *Black Tattoo Art*. Munich, Germany: Editions Reuss, 2009.
- Minguet, Eva. *Tattoo Delirium*. New York, NY: Collins Design, 2009.
- Misser, Kristian. *Inside the Tattoo Circus: A Journey Through the Modern World of Tattoos*. Atglen, PA: Schiffer Publishing, 2008.
- Mitchel, Doug. *Advanced Tattoo Art* (How-To Secrets from the Masters). Stillwater, MN: Wolfgang Publications, 2006.
- Rainier, Chris. *Ancient Marks: The Sacred Origin of Tattoos and Body Marking.* San Rafael, CA: Earth Aware Editions, 2006.
- Saltz, Ina. *Body Type: Intimate Messages Etched in Flesh.* New York, NY: Abrams Image, 2006.
- Sanders, Clinton. *Customizing the Body: The Art and Culture of Tattooing*. Philadelphia, PA: Temple University Press, 2008.

For Further Reading 57

Smith, John. *Inked: Clever, Odd, and Outrageous Tattoos.* New York, NY: teNeues Publishing, 2008.

Superior Tattoo. *The Tattoo Bible: Book One*. Stillwater, MN: Wolfgang Publications, 2009.

- Superior Tattoo. *The Tattoo Bible: Book Two*. Stillwater, MN: Wolfgang Publications, 2010.
- Swallow, Jerry. *Traditional American Tattoo Design: Where It Came from and Its Evolution*. Atglen, PA: Schiffer Publishing, 2008.
- Tattoo Johnny and David Bolt. *Tattoo Johnny: 3,000 Tattoo Designs*. New York, NY: Sterling Innovation, 2010.
- Von D, Kat. *High Voltage Tattoo*. New York, NY: Collins Design, 2009.
- Waterhouse, Jo. *Art by Tattooists: Beyond Flash*. London, England: Laurence King Publishers, 2009.

BIBLIOGRAPHY

- AAA Tattoo Directory. "Tattoo Regulations by State." Retrieved September 2010 (http://www.aaatattoodirectory.com/ tattoo_regulations.htm).
- Alliance of Professional Tattooists. "Basic Guidelines for Getting a Tattoo!!!" 2010. Retrieved September 2010 (http://www.safe-tattoos.com/Basic%20Guidelines%20 for%20Getting%20a%20Tattoo.html).
- American Society for Dermatologic Surgery. "Do's and Don'ts When Considering Tattoos or Piercings." Retrieved September 2010 (http://www.asds.net/ DosAndDontsConsideringTattoosPiercings.aspx).
- Bjarnoson, Dan. "Skin Deep." CBC News Online, October 21, 2004. Retrieved September 2010 (http://www.cbc.ca/news/background/tattoo/skindeep.html).
- Bloginity staff. "Kelly Osbourne Plans Tattoo Removal." October 5, 2010. Retrieved October 2010 (http://www. bloginity.com/blog/2010/10/05/kelly-osbourne-planstattoo-removal).
- Centers for Disease Control and Prevention. "Can I Get HIV from Getting a Tattoo or Through Body Piercing?" March 25, 2010. Retrieved September 2010 (http://www.cdc.gov/ hiv/resources/qa/transmission.htm).
- Clerk, Carol. *Vintage Tattoos: The Book of Old-School Skin Art.* New York, NY: Universe, 2009.

- DeMello, Margo. *Bodies of Inscription: A Cultural History of the Modern Tattoo Community*. Durham, NC: Duke University Press, 2000.
- Discovery Health. "How Tattoo Removal Works." Retrieved October 2010 (http://health.howstuffworks.com/skin-care/ beauty/skin-and-lifestyle/tattoo-removal.htm).
- Gerwig, Pastor Chuckk. "Tattoo and the Bible." 2007. Retrieved September 2010 (http://www.sacredink.net/ tattoo_and_the_bible).
- Gilbert, Steve. *Tattoo History: A Source Book*. New York, NY: Juno Books, 2000.
- Gleason, Kathy. "Contraindications to Getting a Tattoo." March 4, 2010. Retrieved September 2010 (http://www. suite101.com/content/contraindications-to-getting-atattoo-a209259).
- Green, Terisa. Ink: The Not-Just-Skin-Deep Guide to Getting a Tattoo. New York, NY: NAL Trade, 2005.
- Green, Terisa. *The Tattoo Encyclopedia: A Guide to Choosing Your Tattoo*. New York, NY: Fireside, 2003.
- Hardy, Lal. *The Mammoth Book of Tattoos*. Philadelphia, PA: Running Press, 2009.
- Hesselt van Dinter, Maarten. *The World of Tattoo: An Illustrated History*. Amsterdam, Netherlands: Mundurucu Publishing, 2007.
- Jewell, Fred, and Stan Schwartz. "How Does a Tattoo Gun Work?" June 29, 2010. Retrieved September 2010 (http:// www.faqs.org/faqs/bodyart/tattoo-faq/part8/section-5.html).

Krcmarik, Katherine L. "Choosing a Tattoo Artist/Studio." Michigan State University, 2003. Retrieved August 2010 (https://www.msu.edu/~krcmari1/individual/get_artist.html).
Lisbon, Gunnery Sgt. Bill. "Corps Clears Up Tattoo Policy." U.S. Marine Corps, February 4, 2010. Retrieved September 2010 (http://www.usmc.mil/unit/mcasyuma/ Pages/20100204tattoo.aspx).

- The L Magazine. "The 10 Greatest Misspelled Tattoos." July 7, 2008. Retrieved September 2010 (http://www. thelmagazine.com/TheMeasure/archives/2008/07/17/ the-10-greatest-misspelled-tattoos).
- Mayo Foundation for Medical Education and Research. "Tattoos: Understand Risks and Precautions." February 16, 2010. Retrieved June 2010 (http://www.mayoclinic.com/ health/tattoos-and-piercings/MC00020).
- MuslimConverts.com. "Ruling of Tattoos in Islam." Retrieved September 2010 (http://www.muslimconverts.com/ cosmetics/tattoos.htm).
- Richards, Bailey Shoemaker. "How to Choose a Tattoo Artist." October 7, 2009. Retrieved September 2010 (http://www.suite101.com/content/how-to-choose-a-tattooartist-a156709).
- Tao of Tattoos. "Gang and Prison Tattoos." Retrieved September 2010 (http://www.tao-of-tattoos.com/gangs.html).
 The Tattoo Collection. "Choosing a Tattoo Artist." Retrieved September 2010 (http://www.thetattoocollection.com/ choosing_a_tattoo_artist.htm).

- U.S. Food and Drug Administration. "Tattoos & Permanent Makeup." June 23, 2008. Retrieved September 2010 (http://www.fda.gov/Cosmetics/ProductandIngredientSafety /ProductInformation/ucm108530.htm).
- The Vanishing Tattoo. "Tattoo Facts and Statistics." 2003. Retrieved September 2010

(http://www.vanishingtattoo.com/tattoo_facts.htm).

- Winkler, Kathleen. *Tattooing and Body Piercing: Understanding the Risks*. Berkeley Heights, NJ: Enslow Publishers, 2002.
- Zjawinski, Sonia. "What to Expect When Getting a Tattoo." *New York Magazine*, September 24, 2007. Retrieved September 2010 (http://nymag.com/guides/everything/ tattoos/37979).

A

age requirements, 7 alcohol, 38, 39, 40 allergic reactions, 45 Alliance of Professional Tattooists, 33 ambigrams, 34 antibacterial ointment, 47 appointment, making an, 38 autoclaves, 33, 35, 41

B

bikers, 4, 16, 23 blood-borne diseases, 32–33, 35 blood thinners, 10, 38, 39

(

calligraphy, 26 colds and illness, 10

E

equipment, 33, 35, 40-41, 43-45, 48

F

flash, 17, 27, 37 font styles, 26–27

6

gangs, 4, 16, 23

H

hepatitis, 32–33, 35 High Voltage Tattoo, 14 HIV/AIDS, 32, 33

infection, 5, 10, 32, 33, 37, 40, 47, 48

job interviews, 9-10, 19

LA Ink, 14 laser surgery, 48, 49, 50 licenses and certificates, 35, 36, 48

М

Miami Ink, 14 military, 4, 13, 14–15, 19, 22–23, 25

P

pigments, 40, 44–45, 49 portfolios, 30, 31 pregnancy, 10 prisons, 16, 23

Index 63

Q questions to ask, important, 4–5, 10, 12, 13, 16, 17, 28, 29–30

R

registration, city or state, 35, 36

5

scratchers, 36–37 shaders, 43 sterilization, 33, 35, 36, 41, 43, 48

T

tattoo, getting a, choosing a tattoo, 17–28 how it works, 38–50 introduction to, 4–6 shopping around, 29–37 thinking before inking, 7–16 tattoos aging of, 19–20 caring for new, 5, 45–47 celebrities with, 12, 14, 16 cost of, 37 religion and, 8–9, 23, 25, 34 removal of, 12, 16, 48–50

safety suggestions, 48 size/placement, 4, 17, 18-20, 37, 40, 43, 49, 50 sleeves, 15 sunlight and, 20, 47 symbols, 17, 19, 21, 25, 34 tattoo shop, choosing a, 29, 30, 32-33, 35-37, 50 tattoo styles abstract, 22, 27, 28, 34 Asian, 21, 26, 28, 34 biomechanical, 23 black-and-gray, 14, 23 Celtic, 20, 25, 26, 34 Gothic, 23, 26 Haida, 22 Hanzi, 26, 28 Kanji, 26, 28 Native American, 22, 34 personal, 4, 12-13, 17, 24, 27 Polynesian, 22, 34 realistic, 14, 23 traditional, 22, 25 tribal, 22, 28 tetanus, 32

V

vaccinations, 35 Von D, Kat, 14

About the Author

64

Larry Gerber, a former Associated Press correspondent and bureau chief, has been writing news and feature articles for more than forty years. His interest in tattooing began in 2000, when his daughter said she wanted to get a friendship tattoo.

Photo Credits

Cover (top) © www.istockphoto.com/webphotographeer; cover (bottom) Jahi Chikwendiu/The Washington Post/Getty Images; p. 5 © Michele Sandberg/ZUMApress.com; p. 8 Jean-Marc Giboux/Getty Images; p. 11 Mike Zarrilli/Getty Images; p. 13 Mauricio Lima/AFP/Getty Images; p. 15 Robert Nickelsberg/Getty Images; p. 18 © ACE STOCK LIMITED/ Alamy; p. 19 Dave Etheridge-Barnes/Getty Images; p. 21 © Doug Steley A/Alamy; p. 24 © The Commercial Appeal/ ZUMApress.com; p. 27 © Pittsburgh Post-Gazette/ZUMApress. com; p. 31 Douglas Graham/Roll Call/Getty Images; p. 33 iStockphoto/Thinkstock; p. 36 © St. Petersburg Times/ ZUMApress.com; p. 39 © MICHAEL ALLEN JONES/MCT/Landov; p. 42 David Paul Morris/Getty Images; p. 44 © AP Images; p. 46 © Chet Gordon/The Image Works; p. 49 Chet Gordon/ NY Daily News Archive via Getty Images.

Designer: Les Kanturek; Photo Researcher: Amy Feinberg